The Accidental Memoir

Eve Makis and Anthony Cropper

4th ESTATE • *London*

4th Estate
An imprint of HarperCollins*Publishers*
1 London Bridge Street, London SE1 9GF
www.4thEstate.co.uk

This edition published in 2018 by 4th Estate
Previously published in 2017 with the support of
Arts Council England

A catalogue record for this book is available from
the British Library
ISBN 978-0-00-830203-0

Set in Futura

Printed in China by RRD Asia Print Solutions

MIX
Paper from
responsible sources
FSC™ C0C 454

FSC™ is a non-profit international organisation
established to promote the responsible management
of the world's forests. Products carrying the FSC label
are independently certified to assure consumers that
they come from forests that are managed to meet the
social, economic and ecological needs of present
and future generations, and other controlled sources.

Find out more about HarperCollins and the
environment at www.harpercollins.co.uk/green

Acknowledgements

Thank you to the following for believing in the value of personal stories and the health-giving benefits of
writing. Michelle Kane and the team at 4th Estate, Diana Beaumont, Arts Council England, Sandeep Mahal
and Nottingham City of Literature, Henderson Mullin and Writing East Midlands, James Urquhart, Alexandros
Plasatis, Zoe Piponides, Ian Daley, Isabel Galan, Justin Neal, Caroline Connelly, Alexander Masters, Lauren
Mumby, Tasos Makis, Julia Cropper, Emily Cooke, First Story, Guy Herbert, Nottinghamshire Refugee Forum,
Leicester City of Sanctuary and Lincolnshire Action Trust.

Foreword

By Alexander Masters

The Accidental Memoir teaches writing by teaching nothing. Refreshingly, it has no instructions about how to develop character, not a word on dialogue, grammar, pacing, finding your voice, constructing a plot or the five-part structure. Yet, over the next 150 pages, this remarkable manual will coax you out of wordlessness into exposing your life.

The authors, Eve Makis and Anthony Cropper are award-winning novelists and tutors of creative writing at Nottingham Trent University. Their motivating principle is that the only way you can learn to write is by doing it yourself. Using a progression of prompts and exercises (and a few clever sleights of pen – turn to p.38 if you want to be hoodwinked into writing a startling love poem) they direct you through the job of producing a guidebook to yourself, from the origins of your family name and your earliest memories, to composing ranting letters to your enemy, thankful letters to old pets, and what exactly you'd do if you were invisible. They call this lively approach 'scaffolding'. When you've finished all the assignments, pull the printed part of the book away and you'll be left with a well-structured, evocative memoir.

The Accidental Memoir began with Eve. 'I needed a Christmas present for my dad. He had come to England from Cyprus with nothing, spent his first night in a telephone box, built up a community from nothing. But when it came to talking about it, he seemed trapped inside.' She gave him a notebook filled with the life-writing prompts she used for her students, and beside each one left a large space for his reply. 'More than his stories, I wanted to encourage my dad to communicate.' The prototype of *The Accidental Memoir* was a gesture of love.

'True to form, my dad was underwhelmed,' Eve laughs now. 'But I could tell from his eyes that he liked it.' A month later, 'very quietly' he brought the book back to her house.

'I remember losing a younger brother and was told not to bother,' he had written in response to the task on p.49. 'I was told it was God's will and He will send us another. I remember the good old days, slipping on planks of wood and hay. I remember the Easter fire that left us nothing to desire.' It seems right that Eve's family is Greek: it's an Olympian gift that takes an old man out of reticence into poetry.

'If it worked for my father, it can work for anybody,' realised Eve. She joined forces with Anthony Cropper and they secured a grant from the Arts Council to produce a trial edition of three hundred copies, which they then tested in all the places least likely to encourage writers: probation centres, refugee groups and homes for the elderly. *The Accidental Memoir* is a listening book, not a lecturing one; the results were astonishing. 'We've been talking to these people for years and they've not told us any of this,' said officers at one prison after a session with the book. 'The abuse they've suffered, the drugs, their childhoods. You found it out in an hour.'

'You are an Irish jig, the satisfying sight of a freshly ploughed field in the morning, a ride on a rickety roller coaster ...' wrote an inmate, about his son.

'Are you going to send it to him?' asked Anthony.

'I can't,' the man replied, welling up, taken aback by what he'd accidentally revealed. 'It is too strong.'

The Accidental Memoir is more than a provocateur to get you writing well. It has the potential to be a dangerous book: it forces you into mental clarity. It can expose things about yourself that you previously refused to admit, or did not know. It is medicine for your inhibitions. 'I come from a house, pink like a salmon,' wrote a girl at a community school, prompted by another exercise in the book, which gets you to describe yourself in an evocative way. 'I come from a bargain, "only 99p".'

If you want encouragement to write powerful sentences, stuff this book in your pocket and take it everywhere. Treat it with emotional care, but don't respect it physically. Bend it, break the spine, pour coffee on it, obliterate the illustrations, scribble all over it, make it mucky with words. If you run out of space, buy another copy. Fill *The Accidental Memoir* with your life.

You can find poetry in your
everyday life
Carol Ann Duffy

This book can help you:

Write a memoir
Flex your writing muscles
Exorcise your demons
Relive moments of magic
Make sense of life
Reminisce
Create social media content
Become your own therapist
Reduce stress
Have fun
Leave a lasting legacy

How to use this book

Start at the beginning and work your way to the end or flick through the pages and find a prompt that takes your fancy. Some are simple and straightforward; others will take more time and energy. If you're struggling with an exercise leave it for another day.

Don't try to write like a writer.

Don't worry about tone or style or accuracy. Write whatever comes into your head as if you were composing a letter to your best friend. It might help to write the way you talk and don't hold back or self-edit. This is the story of you, a reflection of your personality as much as the telling of your story.

Don't concern yourself with grammar, spelling, punctuation, sentence structure or presentation. Scribble, make notes, underline, draw, annotate and cross out. Give your creativity free rein. Take the book out and about, on the bus, train, in the café, and when you've a spare moment rewind the show reel of your life and put pen to paper. Fill the pages with thoughts and experiences that make up the rich narrative of your life. Writing breeds writing and practice makes perfect. One memory leads to another. You don't need to have lived a life of adventure or high drama to write a memoir.

EVERYONE HAS A STORY TO TELL ...

Who are you?

Are you an introvert or a social animal, short-tempered or Zen-like, focused or easily distracted? Or are you, like most of us, a mix of personalities, full of contradictions. Explore your traits, emotions and desires on the opposing page. Use the guide below if it helps, or just do your own thing.

I AM

I am (three words that describe you)

I want (what are your desires: emotional, material, practical?)

I need (a person, a place, a thing, a state of mind)

I worry (what makes you sad or anxious?)

I dream (about what?)

I love (name three things)

I am (repeat the first line)

I AM

I am

I want

I need

I worry

I dream

I love

I am

On the opposite page draw a map of where you lived as a child. Annotate. Add street names, neighbours, play areas, local shops …

SHOPS PLAY AREAS NEIGHBOURS

Make the writing sensory. Make it real.

Don't just tell it. Show it. Paint a 3-D picture in words. What did you feel when your brother broke your favourite gadget? What did you say, think, experience with your senses? How did the people around you react? Was it raining or sunny, snowing, miserably cold? What sound did he make when you whacked him over the head with a hardback copy of *War and Peace*? What were the consequences? How did he make it up to you, or not? How does he remember the rumpus? Every story has a before and after life.

So, draw on your senses when you write: all five. Train yourself to write this way. The next time you're standing at a bus stop, waiting for the doctor, sitting on a park bench, pay more attention to the sights, sounds, smells and textures around you, the taste in the air.

Under my window, a clean rasping sound
When the spade sinks into gravelly ground:
My father, digging. I look down

The narrator in Seamus Heaney's poem, *Digging*, watches his father skilfully work with a spade in the garden. Heaney used his pen to dig into his past. Use yours to do the same.

Close your eyes for three minutes and imagine the place where you grew up. Try to remember the sounds, the smells, the sights, the textures and tastes. What's above the roofline and under your feet, what's the weather like? When you open your eyes make a list of everything you remember.

I come from a suburb waiting forever
for the train to London,
from smashed windows, graffiti,

In *I Come From* by Robert Seatter, the poet explores recollections of his London suburb.

Write about something that happened in the place you explored on the previous page. Use sensory detail from your list.

Write about a house, flat or room you've lived in and the
memories associated with it. Include as much detail as possible.

**What I remember most is Mango Street,
sad red house, the house I belong but do
not belong to.**

In *The House on Mango Street* Sandra Cisneros writes about
a family house that doesn't quite meet her expectations.

Did your family have ornaments on the mantelpiece or in a display cabinet? A nodding dog, holiday souvenirs, a weird sculpture or trophy? What ornaments do you remember?

Write a story about one item from your list.
Who bought it, won it, made it, broke, sold, inherited or lost it?

Need more space? Go to the back of the book.

GREAT GRANDFATHER

GREAT GRANDMOTHER

GRANDFATHER

GRANDMOTHER

PARENTS

SIBLINGS

What's in a name?

Research your family name. Use the internet, local library,
ask relatives. What does it mean? Where does it originate?

Now your first name? Do you have a nickname? Do you like it?
Were you lumbered with an unfashionable name? What would
you be called if you had the power to change your name?

Nicknames? List them.

Fill this page with local phrases or words used by your parents, friends or relatives. They could be phrases related to another culture, or sayings unique to your family.

There's lots of local dialect in Nicola Monaghan's novel *The Killing Jar* set on a Nottingham council estate.

Paint a portrait in words of someone dear to you, from the present or the past. A parent, surrogate aunt or family friend, a partner or old flame. If it helps start with a description and read the extract below for inspiration. Otherwise, do it your own way.

When people are dead, graves aren't where to find them. They're in the wind, the grass. That's the kind of thing he said.

Read *Portrait of My Father* by Ali Smith. A short piece full of rich and specific detail that captures the spirit of the writer's father.

Family fallouts

We all have them. They happen every day. Write about yours on these pages.

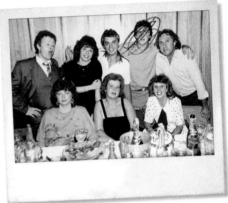

There are so many novels about bad blood and family fallouts. *Anna Karenina* by Leo Tolstoy, *The Corrections* by Jonathan Franzen and *Ordinary People* by Judith Guest. *All Families Are Psychotic* by Douglas Coupland tells the story of the dysfunctional Drummond family and their adventures on a trip to see their daughter's space-shuttle launch.

Make your recollections as real as possible

Use the senses, be specific, write the way you speak and draw on your own emotions

What did you feel at the time?

Sinking heart?

Shivers in the stomach?

Creeping fear?

Boiling rage?

Is there a mystery in your family? A story rarely spoken about, a black sheep? A question mark in family folklore?

FAMILY FOLKLORE

V

X

Y

I BROKE MY ARM AND
BLAMED MY BROTHER

I FAKED ASTHMA AS A CHILD TO GET
ATTENTION FROM MY PARENTS

EVERYONE THINKS THE BUDGIE DIED
OF OLD AGE. I KNOW THE TRUTH

POST CARD

CORRESPONDENCE

ADDRESS

POST CARD

THIS SPACE FOR WRITING

ADDRESS ONLY

33

We often worry when writing. Will I offend anyone? How honest should I be? What if my mother-in-law reads this? It might be worth following William Zinsser's advice: *Your first job is to get your story down as you remember it — now. Don't look over your shoulder to see what relatives are perched there. Say what you want to say, freely and honestly, and finish the job.*

Fill this page with good intentions, with the first lines of memories you will, or will not, write about.

What's the funniest story you've ever heard or the funniest joke you've ever told or the funniest thing you've ever seen?

What can you laugh about in retrospect? We've all had those moments. Embarrassing, awkward, clumsy, ridiculous, funny after the event. Where would we be without a little humour in our lives?

Read *Pulp*, a spoof detective novel by Charles Bukowski.

Is there someone you miss? A parent, close friend or sibling?
What reminds you of them? When's the last time you saw them?
What do you miss?

Oh, I long to see my mother in the doorway.

In the short story *Mother*, Grace Paley writes about how
a particular song spurs memories of family life and in
particular her late mother.

I love …

Think about the things you love. Write a sentence about each and include as much rich detail as possible. Is it the texture, the colour, the aroma, the shape or the feelings inspired that you love? Be as descriptive as you can. Bring the place, the view, the song to life.

Favourite view

Favourite building

Favourite food

Favourite song

Favourite animal

Favourite film

One more of your own

Favourite …

EXAMPLE:

Favourite food. I love Cypriot doughnuts because they're tooth-raspingly sweet, crisp on the outside, soft in the middle and taste of cinnamon and rose water.

Return to your sentences on the previous page. Pull out fragments, anything of interest or vivid or that draws on the senses. And complete the YOU ARE lines below, for example: *You are Cypriot doughnuts. Tooth-raspingly sweet and soft in the middle. You are cinnamon and rose water.*

Leave the title for last.

TITLE

You are

You are

You are

You are

You are

You are

You are

You are

Write down the name of a person who is very special to you.
Who's the first person that comes to mind?

Now use the name of that person as the title to the piece
on the previous page.

—

Perhaps you could read or send it to the person in the title.

Fill this page with quotes you find inspiring. What does the writer William Zinsser have to say about writing? How about Albert Einstein and imagination? Are there any quotes from friends or family that resonate?

Sudden realisation

Write about a moment when your perception of a friend
or someone in your family changed, for better or for worse.

For ten years she'd sworn I was the first.

In *Water Liars* by Barry Hannah the protagonist has a moment of irreversible change when he learns about his wife's past.

List ten questions you wish you'd asked your parents or grandparents.

1.

2.

3.

4.

5.

6.

7.

8.

9.

10.

Collect a new story from one of your relatives.
Call or visit, write, coax it out.

Freewrite

Writing non-stop helps generate ideas.

Set a timer. Three minutes.

Don't concern yourself with spelling, punctuation or grammar.
Let your thoughts flow. Don't self-edit. Just write.

Ready?

Get going. Don't stop. Write about your earliest memory ...

The American artist and writer, Joe Brainard, wrote multiple memoirs using *I remember* as a prompt. He recounted his childhood and tried to remember everything, often in a rambling and seemingly unconnected way. Start your own *I remember* list about a place you used to visit as a child, or a trip you took, or just make a random list of memories as they come. Include sights, sounds and smells. It might help to write as you would speak. So … what do you remember?

I remember

I remember

I remember

I remember

I REMEMBER ...

I remember

I remember

I remember

I remember

I remember

I remember

Write ten lines related to your life starting with the words ...

I OFTEN FORGET ...

I often forget

I often forget

I often forget

I often forget

I often forget

I often forget

Imperfections

No one's perfect, not me, not you, not the woman next door. List some of your foibles, idiosyncrasies, annoying habits, obsessions.

Brush your teeth seven times a day? Spotless house? Lawn mowed to within an inch of its life?

It might help to think about your flaws as seen through the eyes of someone else. A child, a spouse, an enemy.

Many stories are about flawed characters who change and develop. What kind of story would *A Christmas Carol* be if Scrooge was kind and generous?

Write about a situation in which you were brave. Perhaps you stood up for yourself or someone else, jumped from a bridge with elastic tied to your ankles. Were you ever plucky, spirited, determined, intrepid or courageous?

**I thought hard for us all — my only swerving —,
then pushed her over the edge into the river.**

The narrator in William E. Stafford's poem, *Travelling Through the Dark*, makes a difficult moral decision for the collective good.

Desert Island Discs

What's the soundtrack of your life?
Favourite or formative songs from the past or present.

1.

2.

3.

4.

5.

6.

7.

8.

9.

10.

**But sometimes, very occasionally, songs
and books and films and pictures
express who you are perfectly.**

31 Songs is Nick Hornby's personal account
of the music that has influenced his life.

Write a memory associated with one or more of the songs
on the previous page.

Scatter these pages with all your favourite films and programmes from the past and present.

Write about a film that made an impact on your life. Could you go back in the water after watching *Jaws*? Sleep in the dark after *The Exorcist*? Did you find Dad's secret copy of *Debbie Does Dallas* in the loft?

The End

Write some six word stories about your life.

*

*

*

*

*

*

*

For inspiration look up Hemingway's *six word story*.
How many ways can it be read?

Who's your mentor? Your Master Yoda?

Write a short description of that person. What have they taught you?

What would you change if you were in charge of the world?

If I were in charge of the world there'd be …

1.

2.

3.

4.

If I were in charge of the world there'd be …

5.

6.

7.

8.

If I were in charge of the world there'd be …

9.

10.

**If I were in charge of the world
You wouldn't have lonely.
You wouldn't have clean.**

Judith Viorst imagines what life would be like if only
we could make changes, both real and impossible.
Read *If I Were in Charge of the World.*

If you could be invisible what would you do and where would you go?

The mad scientist in H.G. Wells' *Invisible Man* uses his powers
to perform evil deeds.

Have you ever wanted to escape a situation? Wanted to close your eyes and disappear, have the ground swallow you up? An excruciating dinner party or wedding, a holiday with friends or family? Did you ever dream of escape?

Guests at the barbecue in *The Slap* by Christos Tsiolkas wish they'd never arrived when a child misbehaves and a parent takes drastic action.

Change

Has there been a moment of dramatic change in your life? Have you walked out of a job, changed direction, left a relationship?

What are your biggest regrets?

Write about something you've never told anyone. Write with the knowledge that after it's done you can tear out the page and bin it, shred it or burn it.

How did revealing a hidden truth on the previous page make you feel?

Some sensory words to help with the next prompt.

EXCITEMENT

Dazzling, soaring, sweet, bubbly, buzzing, chirpy, fruity, tingly, fizzing

FEAR

Fumbling, trembling, clammy, piercing, bitter, numb, smothered, jittery, acrid, sweaty, stinging

Fear

Write about a moment of fear and panic.

I have seen my daddy drown but I don't say a word. I lie there with the sea or my heart roaring in my ears.

In the seaside extract from Lesley Glaister's novel *Easy Peasy* the narrator writes about a moment when the bottom fell out of her safe child's world.

The devil is in the detail

Give things the grace of their names. What was the tree you climbed as a child? Name it. Was it oak, sycamore or apple? Your dad didn't just wear shoes. He wore loafers, brogues or Dr. Martens. A dog's not just a dog. Did you own a faithful Labrador called Charlie, a rebellious terrier by the name of Samson or a curly black poochon?

Try being as specific as you can in the next exercise to bring life to your story. Where were you? Who were you with? What time of day was it? What were you wearing? What was said?

For more writing advice read Natalie Goldberg's *Writing Down the Bones*.

Dramatic weather

Have you ever been caught in a terrible storm? Been soaked in
torrential rain, experienced the terrifying crack of thunder up a
mountain? Do you have any memories associated with especially
intense weather?

**Everything outside was in a rage of wind and sleet,
we were children, brothers, safe in the back seat,
for once not fighting, just listening, watching the storm.**

Dramatic weather isn't the only thing on Alan Shapiro's mind
in the poem *Sleet*, but you'll have to read it to find out.

Writing can cast a spell on the reader. It can transport us to another world. When we write, we might consider the way we write. Sentence length is important. Short sentences are punchy. They alter voice, sound, tone. Short sentences have impact. Immediacy. Some prefer a stripped-back style. But, be careful. Too many short sentences can be repetitive, even boring. Longer sentences can draw us in and carry us along with the rise and fall, the rhythm and beat, the musicality of words. So mix the two. Experiment.

Write about a memory from when you were younger. Use short sentences. When you have finished, read it out loud.

Now write about another memory using longer sentences. Include a metaphor or simile to describe the experience; life writing is a road trip into the past and the journey can be illuminating, revealing and ultimately rewarding.

Bohumil Hrabal's novel, *Dancing Lessons for the Advanced in Age*, is just one long sentence. Try experimenting with sentence length in the following exercise.

Favourite hiding place

Where did you hide when you were young? Did you ever build
a den in the garden, in the woods, under a pier, in your bedroom,
up a tree? Our favourite nooks can be like dens to us, a way of
hiding in plain sight.

In *Stig of the Dump*, by Clive King, Barney falls over the edge of an
old chalk pit and finds a caveman's den the perfect place to hide.

Which place holds significant memories for you? Country, city, town, street, back yard. Where is your moveable feast?

If you are lucky enough to have lived in Paris as a young man, then wherever you go for the rest of your life, it stays with you, for Paris is a moveable feast.

PARIS

A Moveable Feast is a memoir by American author Ernest Hemingway about his years as a struggling young expatriate journalist and writer in Paris in the 1920s.

Have you ever returned to a place and been surprised or disappointed by the change? Maybe a city that's been redeveloped or woods that have disappeared. Your childhood home, old school, a place you used to go on holiday. What was it like before?

Read *A Rose for Winter* by Laurie Lee. Fifteen years after his travels in Spain the writer returns to Andalusia and is disappointed by the rapid sweep of change caused by the havoc and destruction of the Spanish Civil War.

Is there somewhere you've dreamed of living: house on the hill, shack by a lake, property abroad? Some people like to imagine the perfect life, an alternative existence. What's yours?

Elizabeth Gilbert didn't just dream. She set off across Italy, India and Indonesia in search of inner contentment and documented her experiences in the memoir, *Eat, Pray, Love*.

Have you ever been taken somewhere you wish you'd never been?
Or seen something you wish you hadn't seen?

Slaughterhouse-Five, Kurt Vonnegut's novel, is based on his experience as a prisoner in the Second World War when he was held in a slaughterhouse during the Dresden bombings.

Burn burn burn

What's been your longest road trip or journey?
The most enjoyable or stressful or memorable?

In the film *Burn, Burn, Burn* a group of young people
scatter their friend's ashes on a road trip across England.

Have you ever had a fight or been involved in a heated verbal altercation? Road rage, shop rage, school fight, pub brawl, family row? Relive that moment.

Rebel rebel

What's the most rebellious thing you've ever done?
How did you feel at the time? Reflect on the experience.

In the memoir, *As I Walked Out One Midsummer Morning,*
Laurie Lee leaves the security of his Cotswold Village in the
1930s to make a living playing violin outside street cafés
in London before heading for Spain.

Truth and lies

Did you ever tell a lie? Big or small? Was it for the better good?
Did it hurt anyone? Did anyone ever find out?

In *Billy Liar* by Keith Waterhouse a young Englishman dreams
of escaping his working-class family and dead-end job as an
undertaker's assistant. A series of lies require him to run away,
leaving behind the mess of his life.

Fifty-thousand people watch a football match and all have a different version of events. Be as honest as you can in this book but don't leave out incomplete memories. Tell your story as YOU remember it, even if you're not quite sure of what actually happened. This is your story, your interpretation of events coloured by your individual life experiences. Everyone has their own truth. What's yours?

Feel free to use the following footnote: NB The event described may not be entirely accurate but is recorded in good faith.

Unreliable narrator

Write about a memory that may or may not be accurate. Something that happened in childhood perhaps, which you, a sibling, or a friend remember differently, such as who broke the Ming vase?

One-breath memory

Write about a childhood memory factually true or exaggerated
that can be read out loud in the time it takes to exhale.

Remember to breathe in. Now do another …

Try again taking inspiration from *Poem to be Read in One Breath:
Blue* by Julia Bird in the collection *Twenty-Four Seven Blossom*.
A poem about bathing a toddler.

Food Heaven

Dishes to die for from the past or present.

1.

2.

3.

4.

5.

Food Hell

Nightmare foods that haunt you.

1.

2.

3.

4.

5.

Taste

TART
TASTELESS GOOEY
RIPE TANGY CREAMY
NUTTY PEPPERY SPICY SWEET
BITTER SAVOURY STRONG COOL
DELICIOUS SOUR MILD TASTY
JUICY SALTY
ACIDIC HOT

Think about the best or worst meal you've had. Describe the look, taste, aroma and texture of the food. Why was it so good or bad? Where were you and who were you with? Include as much detail as you can.

And oh, that pan-fried chow mein flavored air that blew into my room from Chinatown, vying with the spaghetti sauces of North Beach – nay, the ribs of Fillmore turning on spits!

In Jack Kerouac's autobiographical novel, *On the Road*, food culture is mapped out on the writer's journey across the American landscape to create a sense of place.

Favourite childhood meal. Write down the recipe as you remember or imagine it.

Accuracy not essential. Who cooked it? What ingredients did they use? This may be a hand-me-down recipe or one you crave and wish you had learned to cook.

DISH:

NAME OF COOK:

LOCATION:

PREP TIME:

INGREDIENTS:

METHOD:

Cook it.
Give it a try.
Look up the recipe if memory fails.

Contents

Cakes

stir the flour with a little cold milk

Who cooked the most memorable meals in your life when you were young? Mum? Dad? Grandmother? Write about that person cooking. Chopping fresh herbs, kneading bread, wearing a silly apron, drinking wine, listening to music, juggling with knives. Is there a cooking story associated with that person?

Rituals and superstitions

Do you walk under ladders? Throw salt over your shoulder? Put your left sock on before your right? Believe in the predictive power of tea leaves? What illogical beliefs do you harbour?

Coincidence

Have you ever had any strange things happen? Bumped into your neighbour on the other side of the world? Seen a long-lost friend just after you'd thought about them?

American novelist Anne Parrish was browsing in a second-hand bookshop when she came across *Jack Frost and Other Stories*, a childhood favourite. Opening the book she found the inscription Anne Parrish and realised it was once hers and had made its way across the Atlantic.

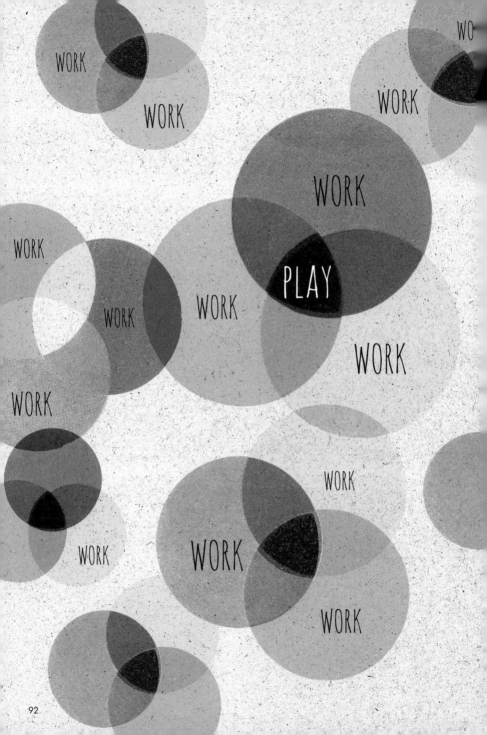

List the jobs you've done. Short-term, part-time, full-time. Which were the most rewarding, challenging, tedious, tiring, inspiring? Did you ever get the sack? Walk out or lose a job?

Write about someone you've worked for. A memorable boss, manager, department head. What were they like?

Works do or office party. Any unforgettable ones?
What happened?

The Chinese word for crisis is composed of the symbols for danger and opportunity.

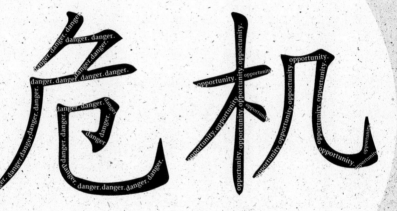

Leap of faith

Change can often be scary but ultimately rewarding. Have you ever tried something new or risky? Left a job, a partner, taken a gamble on the stock market? What happened?

First you jump off the cliff and build your wings on the way down.

In *Zen in the Art of Writing*, Ray Bradbury describes how he spent years trying to be a writer and getting rejected before deciding to leap into his stories without too much planning.

Thought experiments

Have you ever invented anything? Thought of a product just
before it hit the mass market? Had any wild ideas that people
laughed at or you kept to yourself? If possible draw a diagram
of your invention and annotate.

Do you, or did you, have a BIG dream? What is or was it, and why?

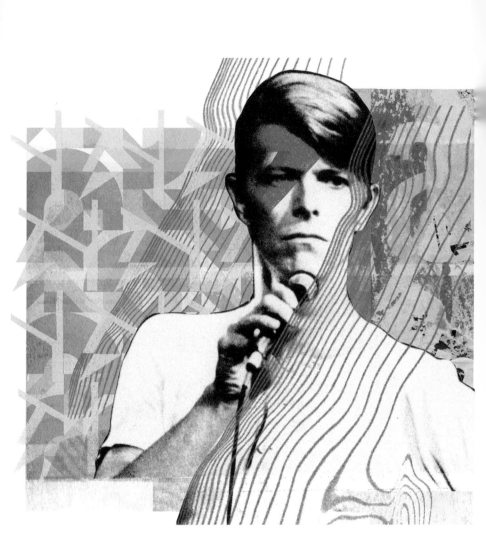

Idols, heart-throbs and heroes? Who were yours and why?

What posters or pictures did you have on your bedroom wall?
Describe one in fine detail.

Fill this page with things from the past or present related
to the colour blue.

List your hopes.

I HOPE ...

1.

2.

3.

4.

5.

6.

7.

8.

9.

10.

Write a wish list. It doesn't have to be literal, practical or even possible. It could be courage like the lion in *The Wizard of Oz* or a Himalayan elephant to carry you across the plains of Tibet.

I WISH FOR ...

1.

2.

3.

4.

5.

6.

Read *The Magic Box* by Kit Wright.

Giving things up

Think of something you've done in the past or more recently, and given up. Why? Do you miss it?

**I used to iron everything:
my iron flying over sheets and towels
like a sledge chased by wolves over snow;**

The narrator in Vicki Feaver's *Ironing*, describes giving up the joy of pressing clothes and converting to *crumpledness* before retrieving the iron from a high cupboard and breathing in the *sweet heated smell of hot metal*, once more.

Rant space

1.

2.

3.

4.

5.

6.

7.

8.

9.

10.

Write a list of all the words and phrases you would use if you were really angry. Don't hold back. You're allowed to swear.

NOW ... use some of the words or phrases on the previous page
to write a letter to someone who has let you down. Or write an
apology that's been preying on your mind.

DEAR ...

**Compliments of the season to you, and
may the acid rain fall on your joint
and anointed heads.**

In *Sense of an Ending* by Julian Barnes the protagonist,
Tony Webster, writes a vitriolic letter to his ex and later
on in the book an apology is required.

Speakers' corner

If you were granted a fifteen-minute slot in Hyde Park to share your views, thoughts and personal philosophies, what would they be? Write your speech or just make notes.

What's been your biggest waste of money? Or have you been ripped off?

Write a list of things you carry, physical and metaphorical.
What's in your bag, your pocket, your heart? Emotional baggage
or treasured possessions, resentments, regrets, precious memories?

**Pocket knives, heat tabs, wristwatches, dog tags,
mosquito repellent, chewing gum, candy, cigarettes,
salt tablets ...**

In *The Things They Carried*, Vietnam veteran Tim O'Brien lists the
survival essentials and personal artefacts soldiers carry into war,
as well as emotional cargo like love, humping it up the hills and
through the swamps.

SOME MORE THINGS WE CARRY ...

Writing ... allows you to work through some of life's hardest knocks — loss, grief, illness, addiction, disappointment, failure — and to find understanding and solace.

William Zinsser

What have you been addicted to? Programmes, chocolate, alcohol or something more destructive? What's the appeal of your addiction?

Kick is momentary freedom from the claims of the aging, cautious, nagging, frightened flesh.

In his semi-autobiographical novel, *Junkie*, William Burroughs focuses on his life as a drug user and dealer.

Illness

Write about an experience of being ill. Fever, migraine, bad back?
Had hot olive oil poured into your aching ear? Or regular hospital visits?

**I think accepting the unsavoury situations which
jump out at us unbidden, is the first step to giving
them a great big slap in the chops.**

Jackie Buxton's *Tea and Chemo*, a wonderful book about fighting
cancer and living life, is a must-read. All proceeds from the sale
go to cancer charities.

Find a photo album. Choose a picture that conjures up a vivid memory. Write about it.

Facades

Most people present an edited version of their reality to the world. The perfect pout, the perfect job, the perfect Sunday roast. Find a picture. One that presents an ideal image of your life. Now, dispel the myth. Write about what happened before or after the photo was taken. What's beyond the lens, behind the smiles?

School Days

Do you have a favourite teacher? Someone who took the time to listen, who sparked your passion for particle physics or recognised your hidden talents. An empathetic, determined, creative educator? Write about him or her. How did they shape your life? What lessons did you learn?

No favourite? Who forced you to eat stodgy swede, chased you with a ruler, made you play rugby in a blizzard?

For inspirational teaching see Robin Williams in *Dead Poets Society*.

Superintendent Gradgrind in *Hard Times* by Charles Dickens thinks of his students as empty vessels to be filled with cold hard facts.

Write about a time when someone left home. A sibling, a child,
a parent or partner. What effect did it have on you?

Who were your close friends when you were young? What were their
names? Write one line on your most vivid memory with each person.

1.

2.

3.

4.

5.

Objects

Think about a personal possession with emotional significance —
a piece of jewellery, a watch, a book, something you've made
or inherited. Describe it. Why is it important? Who gave it to you?

Write about a time you wore fancy dress? Who were you and what did you wear? Where were you going? If you've never worn fancy dress and hate the whole idea — why?

Write a list of all the pets you've ever had or pets in your extended family. Be specific. Use names.

Write a letter of thanks to one of your pets.

Matt Haig's novel *The Last Family in England* is narrated by a black Labrador called Prince who devotes his time to protecting his human masters as they experience marital breakdown, rowdy teenage parties and attempted suicide.

Write a letter to your younger self. What advice would you give?
Would you tell yourself to work harder, play harder, not to take
life so seriously?

AND FINALLY ...

Look back at the all the stories you've written, the lists you've created, the foods you've eaten, the friends you've known, the things you've remembered and forgotten, the places you've lived, the scars, hurts and mishaps. Is there a common theme or thread that runs through your life? You may spot it immediately or it might take some time.

Are most of your memories focused on one person — your mother for instance? Is there an object that recurs? Are you hooked on a place? Are you an addictive personality?

We all have our priorities, preoccupations, interests and dominant emotions. Here are some examples of common themes: family, romance, love, home, grief, illness, addiction. It might help to scatter the page with possible themes and then ring the most important or prominent.

Grappling with a title might help you identify the theme. If your life was a book of short stories or a published memoir, what would it be called?

How to Be a Woman, Caitlin Moran's satirical memoir documents the writer's life from early teens to mid-thirties and the title's a perfect fit.

NOTES

This book was lovingly created by the daughter of a fish fryer who had the foresight to delve and the son of a fisherman who wishes he had asked ...

Eve writes on trains, planes and in automobiles waiting for her son to finish football practice. She has drawn on her own family stories to write four novels and an award-winning screenplay. When Anthony's not teaching Creative Writing he's writing books and radio plays and when he's not writing you'll find him drumming with his band. Both teach on the MA in Creative Writing at Nottingham Trent University.

Appendices

Quote by Carol Ann Duffy taken from *Daily Mirror*, 'Carol Ann Duffy: "Poetry is in your everyday life, your memory, in what people say on the bus .. or just what's in your heart"' (2 May 2009); Extract from 'Digging' by Seamus Heaney taken from *Death of a Naturalist* (Faber & Faber, 1966); Extract from 'I Come From' by Robert Seatter taken form *On the Beach with Chet Baker* (Seren Books, 2006); Extract from *The House on Mango Street* (Arte Publico Press, 1984) by Sandra Cisneros; Extract from 'Portrait of My Father' by Carol Ann Duffy taken from *Granta Magazine*, Fathers Essays & Memoir, Volume 104 (Nov. 2008); Extract from 'Water Liars' by Barry Hannah, taken from *Airships* (Alfred A. Knopf, 1978); Extract from 'Travelling Through the Dark' by William E. Stafford from *The Way It Is: New and Selected Poems* (Greywolf Press, 1998); Extract from *31 Songs* (Penguin, 2002) by Nick Hornby; Extract from 'If I Were in Charge of the World' by Judith Viorst taken from *If I Were in Charge of the World and Other Worries: Poems for Children and their Parents* (Atheneum Books, 1981); Extract from *Easy Peasy* (Bloosmbury, 1998) by Lesley Glaister; Extract from 'Sleet' by Alan Shapiro taken from *Song and Dance* (Houghton Mifflin, 2002); Extract from *A Moveable Feast* (Scribner, 1964) by Ernest Hemingway; Extract from *On the Road* (Viking Press, 1957) by Jack Kerouac; Extract from *Zen in the Art of Writing* by Ray Bradbury (Copra Press, 1990); Extract from 'Ironing' by Vicki Feaver taken from *The Handless Maid* (Jonathan Cape, 1994); Extract from *The Sense of an Ending* (Jonathan Cape, 2011) by Julian Barnes; Extract from 'The Things They Carried' by Tim O'Brien taken from *The Things They Carried* (Houghton Mifflin, 1990); Extract from *Junkie* (Ace Books, 1953) by William S. Burroughs; Extract from *Tea and Chemo: Fighting Cancer, Living Life* (Urbane Publications, 2015) by Jackie Buxton; Excerpt from 'Mother' by Grace Paley taken from *The Collected Stories of Grace Paley* (Virago, 1994); Quotes from William Zinsser taken from *Chicago Tribune*, 'Remembering a literary mentor: How to write well, by the book' (14 May, 2015).